Published in the United States by Red Mountain Press,
P O Box 32205, Santa Fe, New Mexico 87594.
redmountainpress@earthlink.net

ISBN: 978-0-9799865-3-6

Printed in Canada

CONNECTIONS

A Visual Journal

FORD ROBBINS

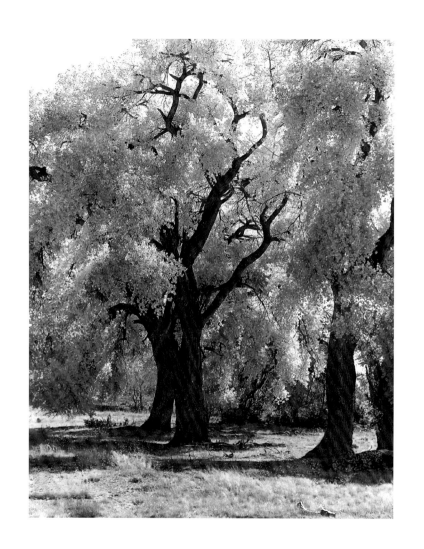

TO MARGARET

PHOTOGRAPHER'S NOTE

I have photographed for a considerable period of time. My work is focused on the land and our connection with the land. This book is a visual journal of my encounters with what was before me.

I am interested in the essence of things, how light creates that essence, and how I relate with that essence. I cannot define what stops me, what causes me to pause, but something draws me in. For me, every photograph is primarily a moment of being alive, of living, of connecting; it is only incidentally a record of historic fact or time.

I "create" on film, yet that is not possible without a deep embrace of what is in front of me. I intend that my image reveal something more than the object in it, and to move you, the viewer, to a higher level of sensual awareness of the world we live in.

Today it seems that we draw our connections to "reality" from a world of "electronically-generated vistas and engineered pleasures," as David Abram has described. I am not interested in "virtual" reality. I draw my link to reality from direct experience. I try to translate that experience into the images I create. Lorine Niedecker eloquently reminds us that "in every part of every living thing / is stuff that once was rock / In blood the minerals of the rock."

My tools are simple: a mechanical camera loaded with film, a tripod, and a light meter. Prints are made in a darkroom using chemicals. I enjoy working with my hands. The materials that I use have taught me much. I need the feedback the materials give me; I cannot get that from a monitor. I also respect the tradition and teaching of my mentors. I want to carry that tradition forward in a new way. I readily accept the new digital tools, but I believe there is a place for the use of the old tools, and I prefer to use them.

He had been wrong to think of light as a veil, playful and shimmering, between him and solid things. That was how a young man saw things, in midsummer, and at midday. But now, especially in the early morning and in the evening, he saw it for the illusion it was. He had to look through things now, since nothing is solid, to show how light and those things it illumines are both transubstantial, both tenuous.

... Eva Figas, *Light*

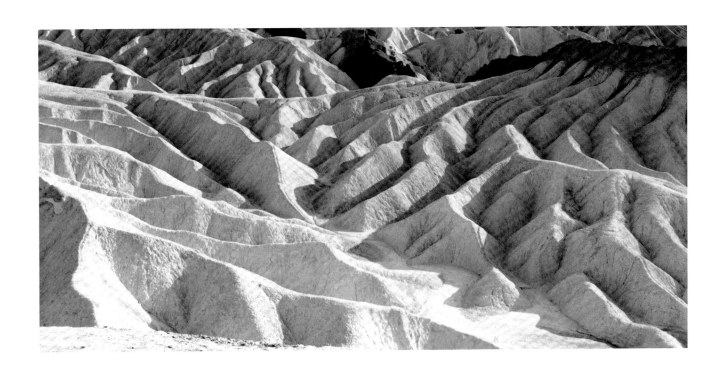

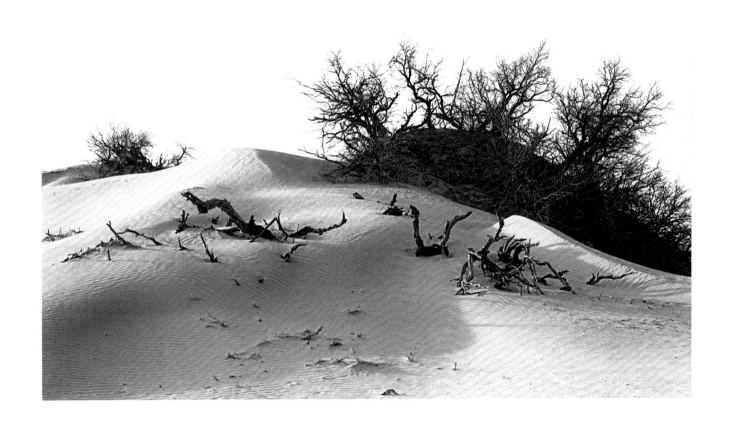

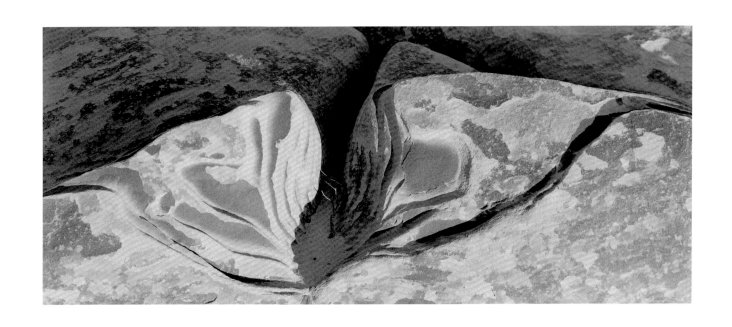

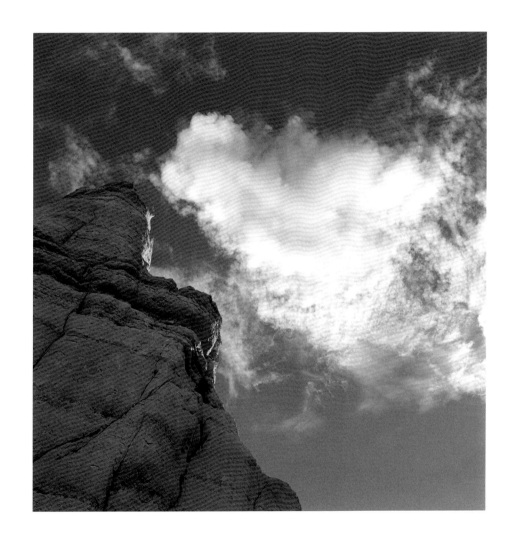

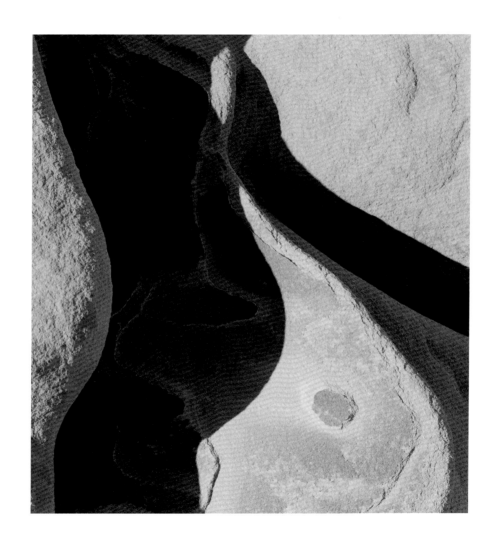

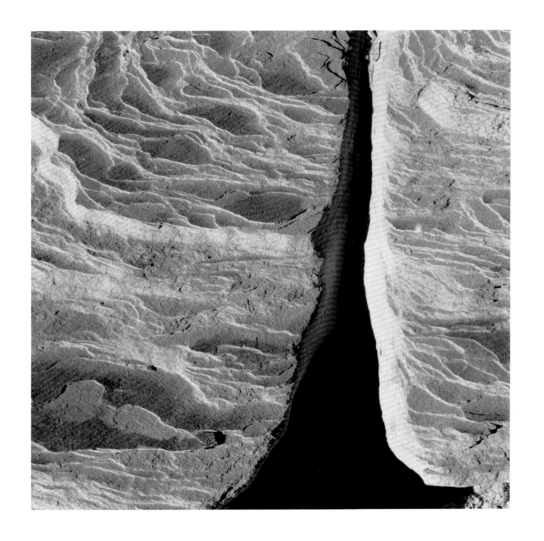

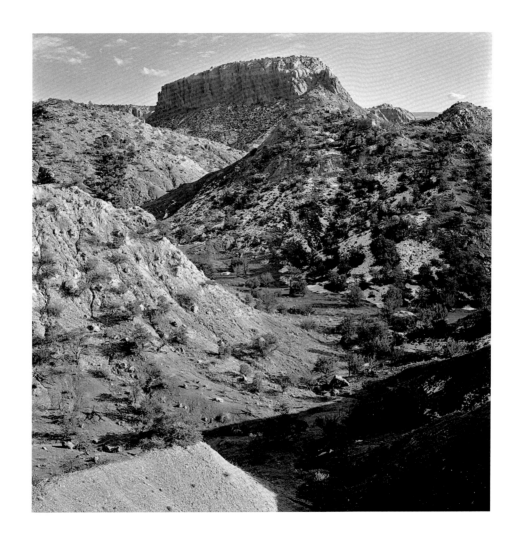

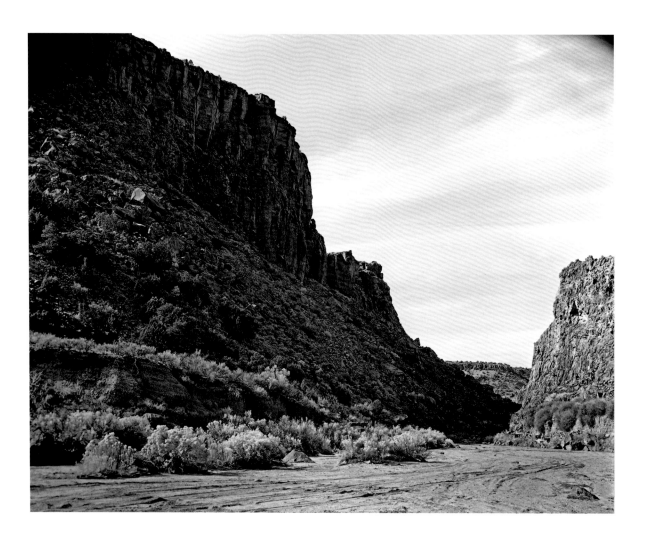

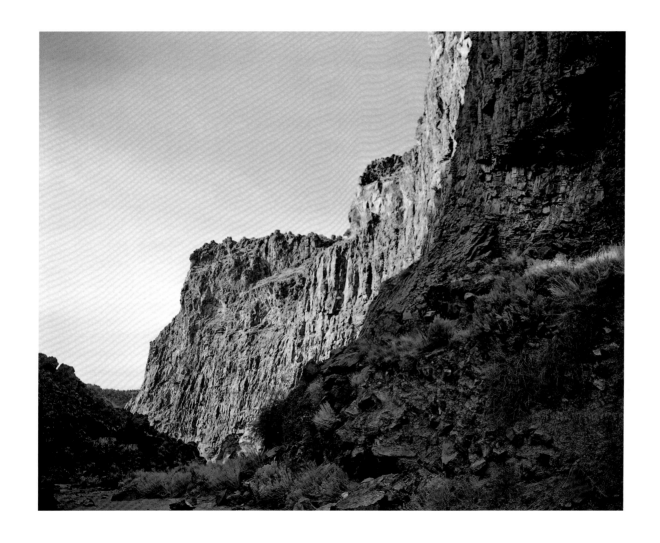

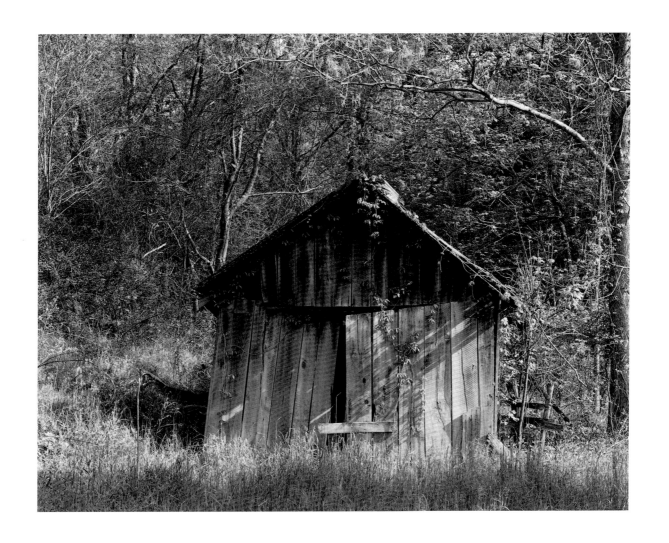

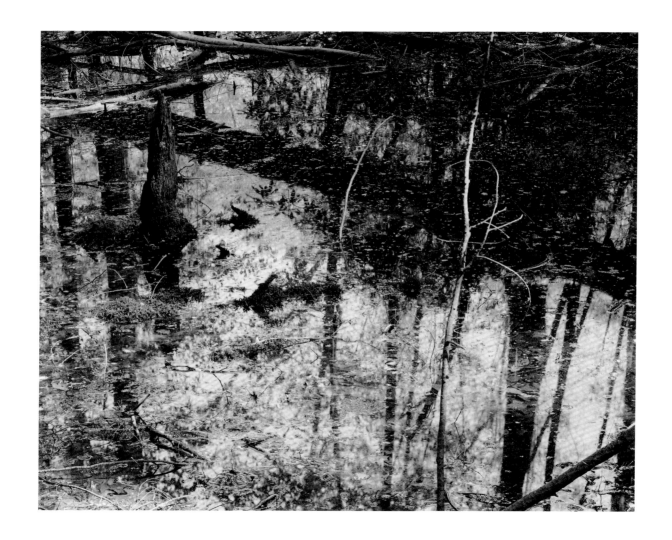

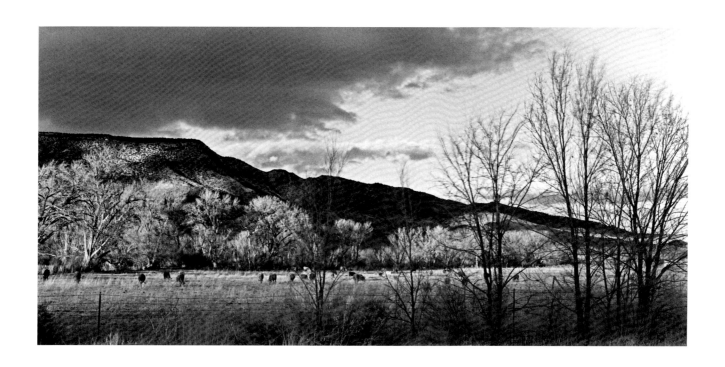

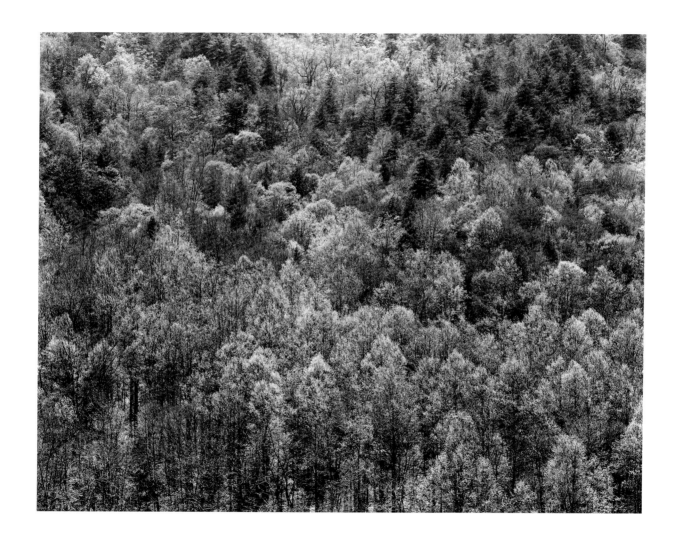

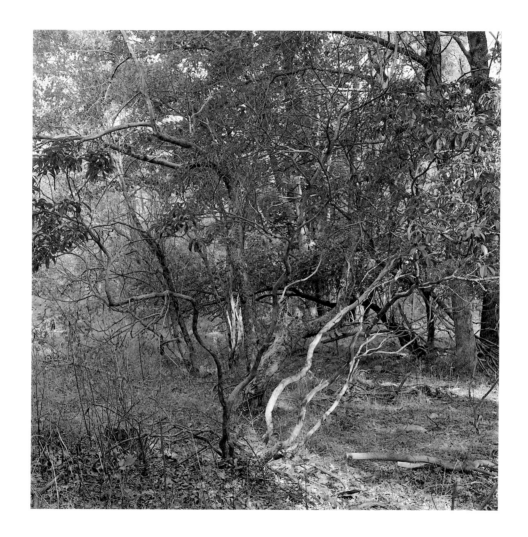

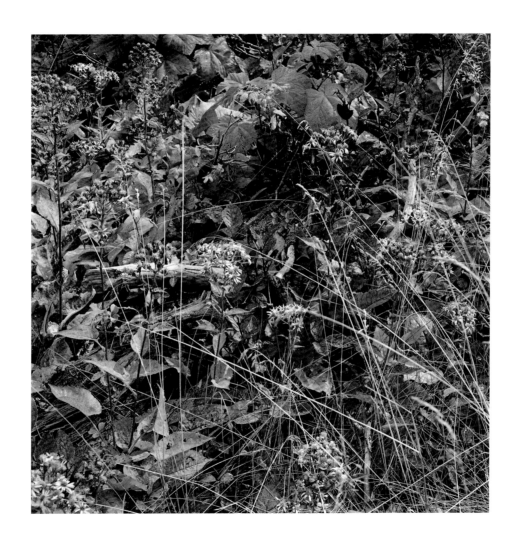

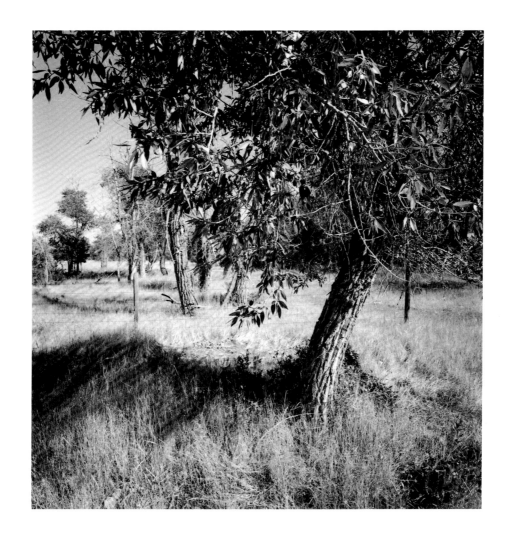

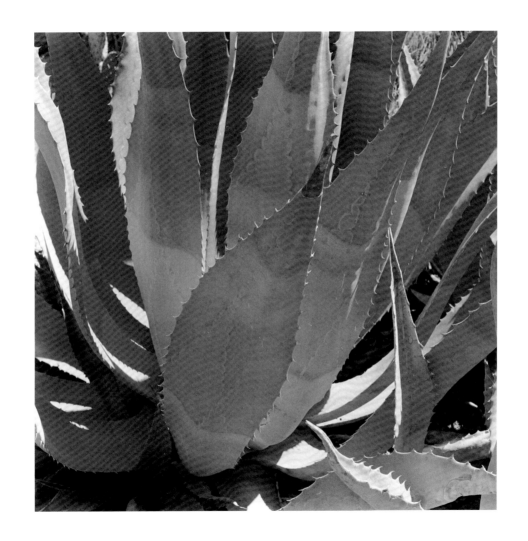

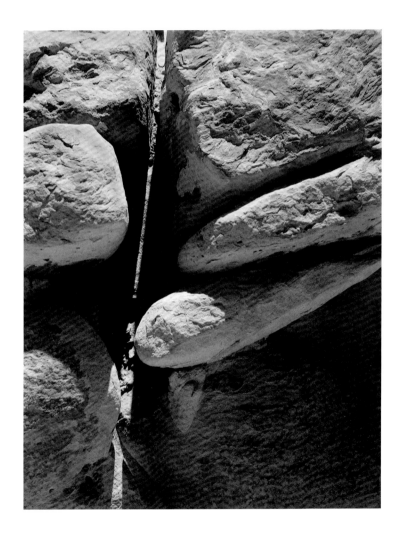

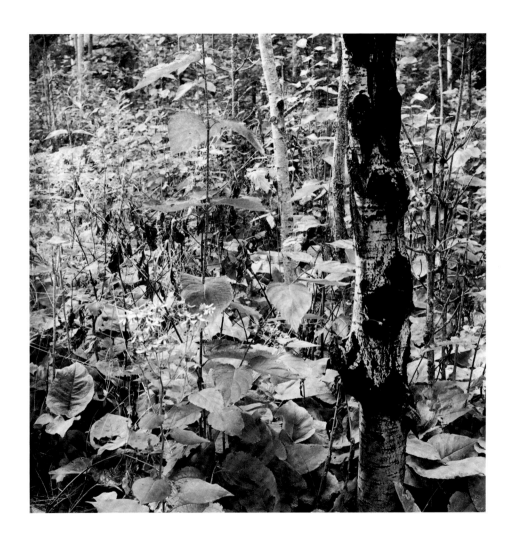

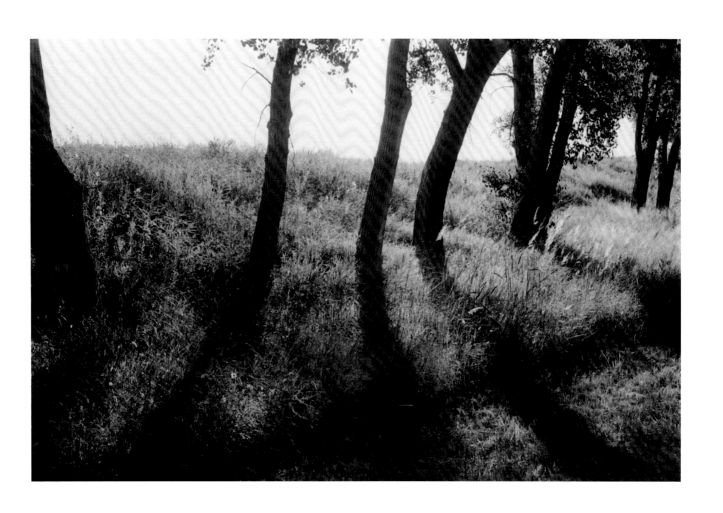

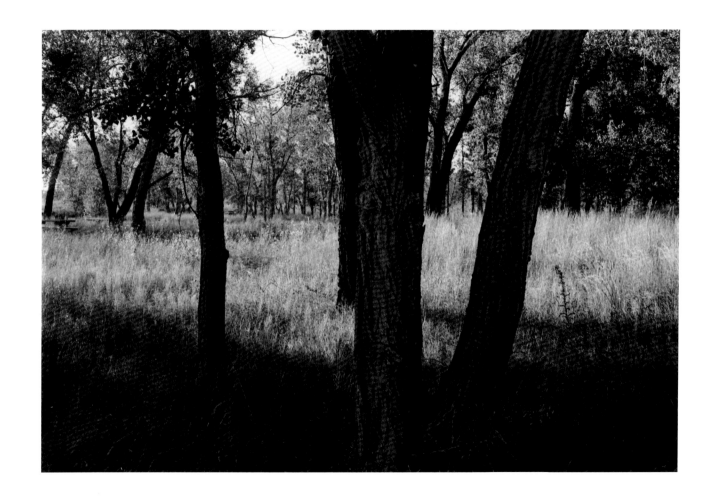

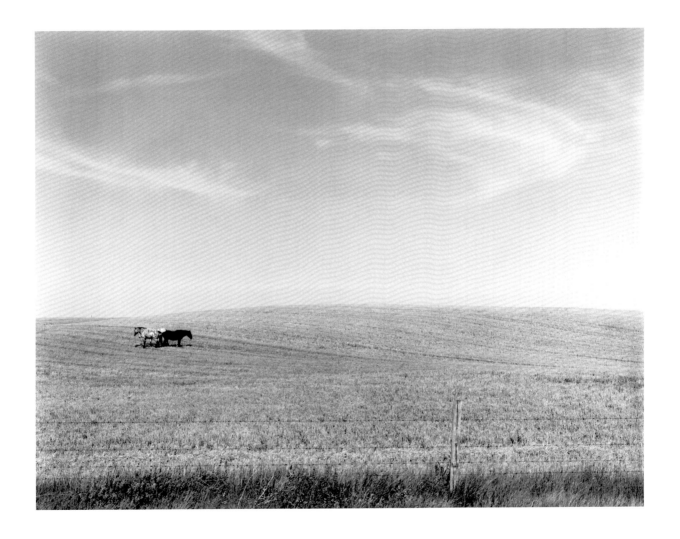

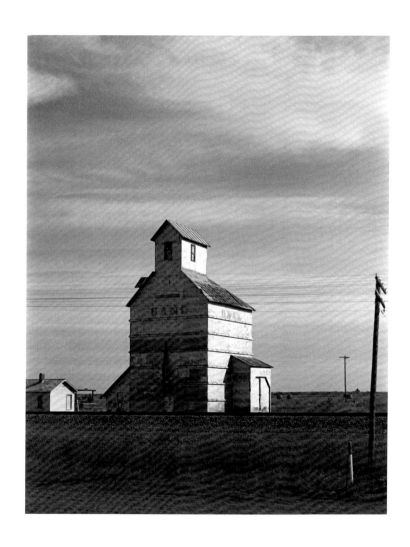

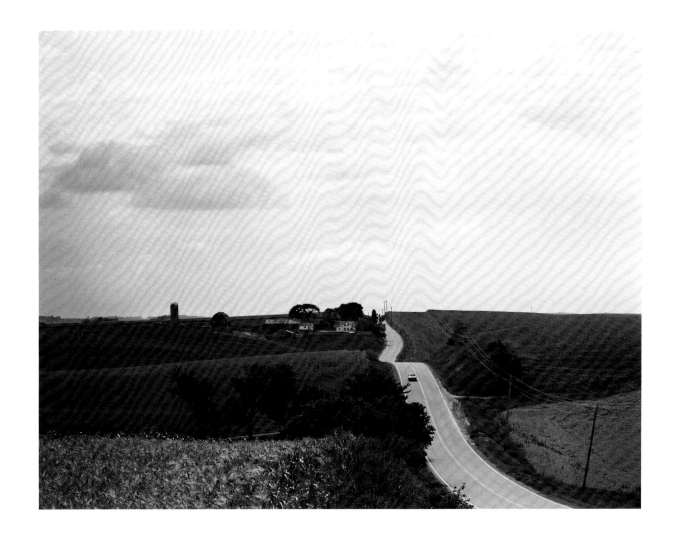

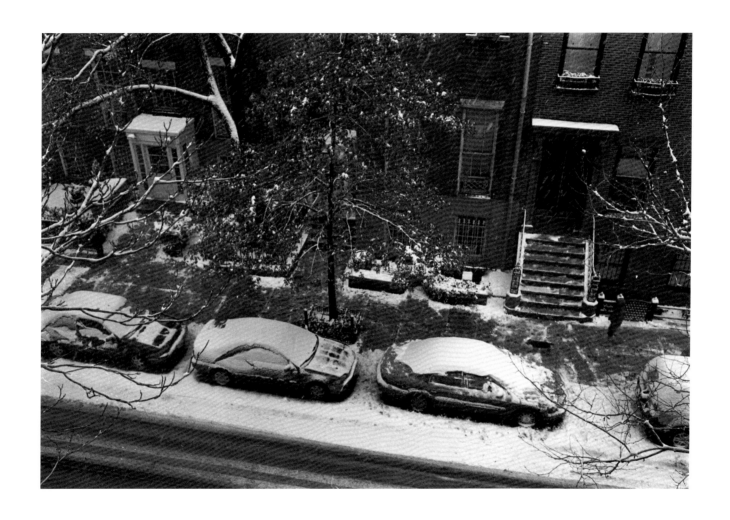

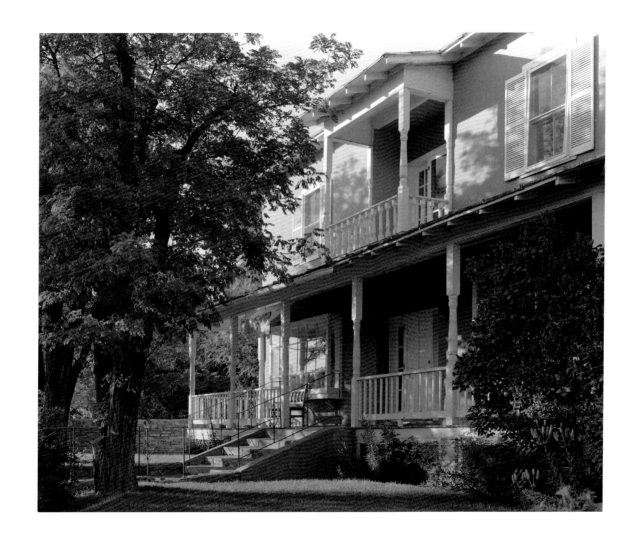

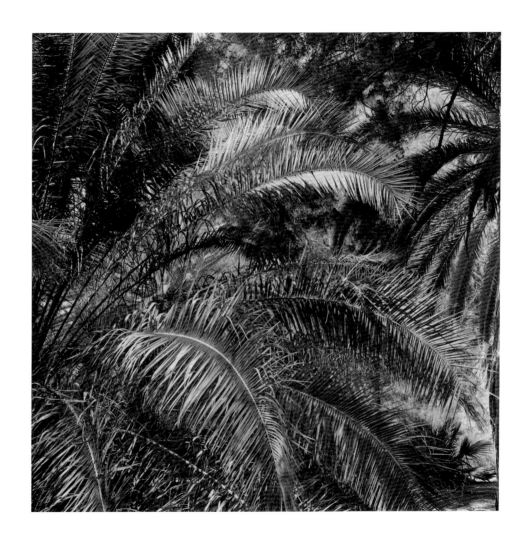

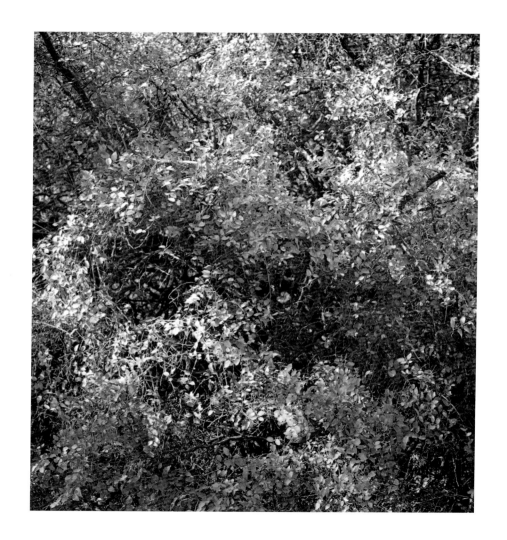

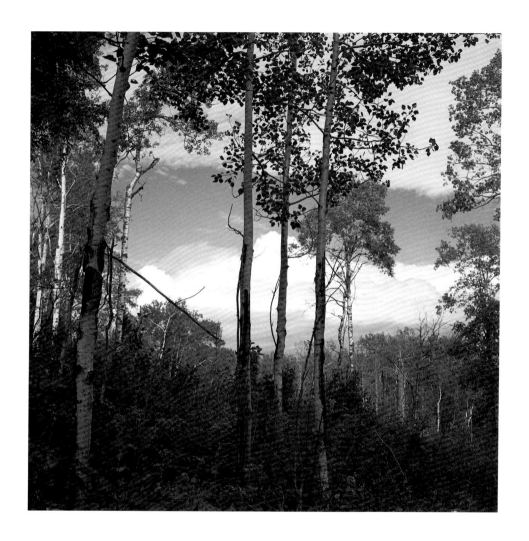

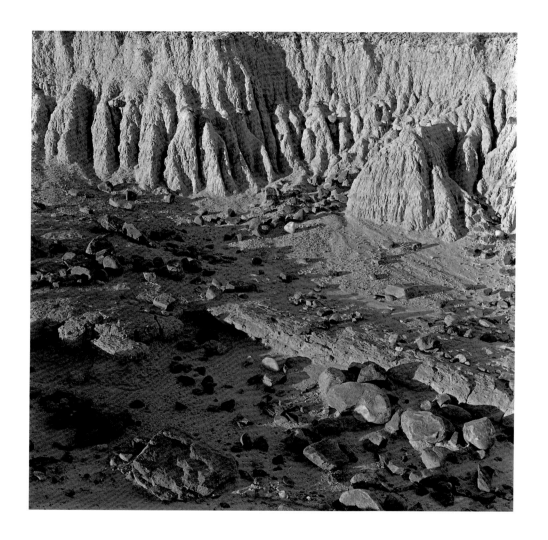

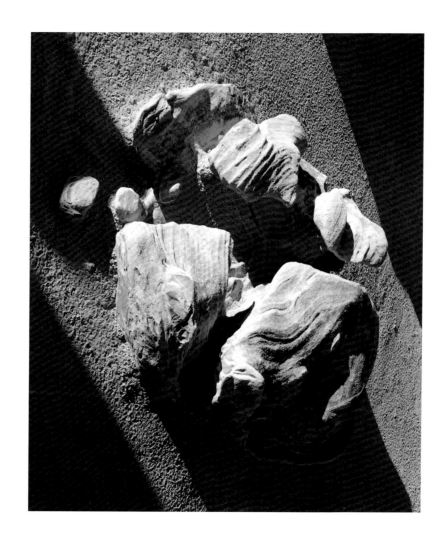

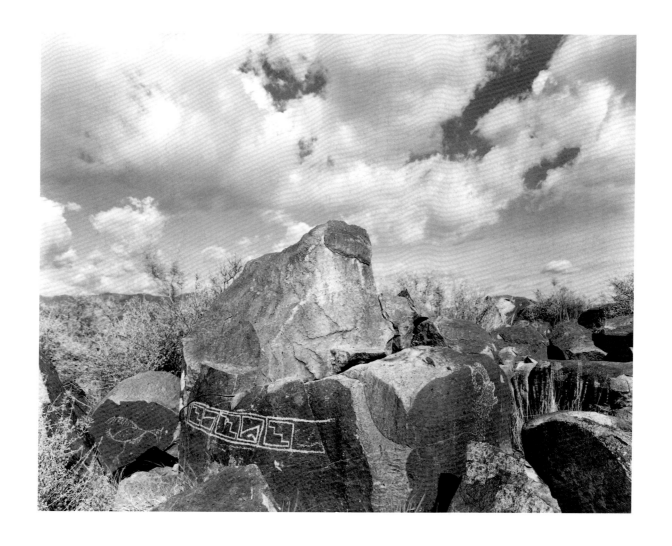

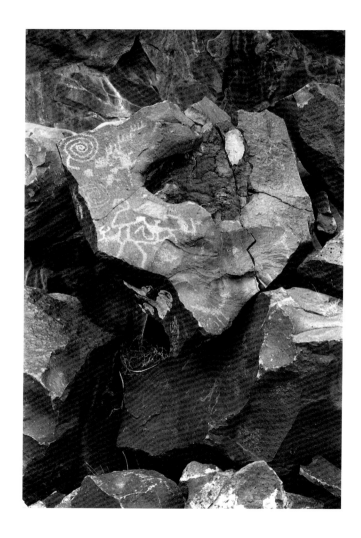

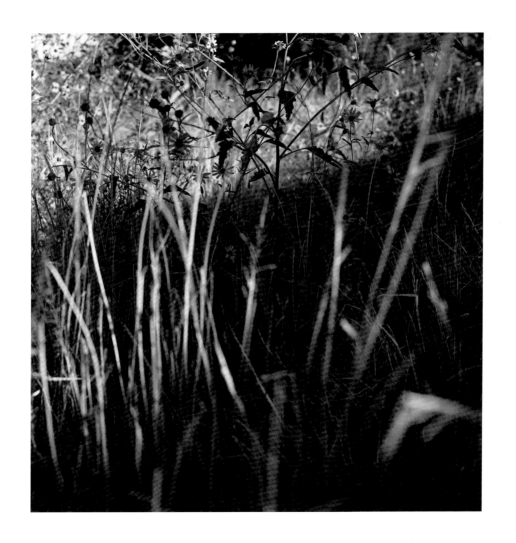

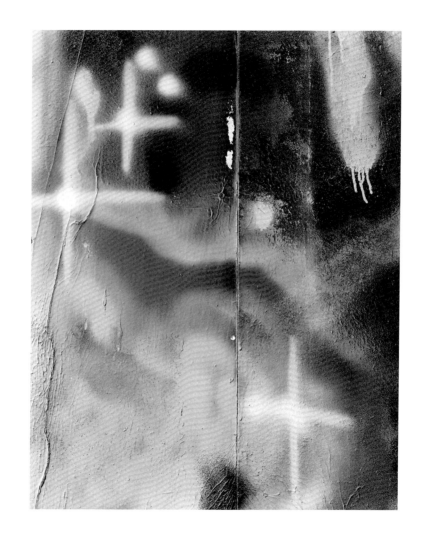

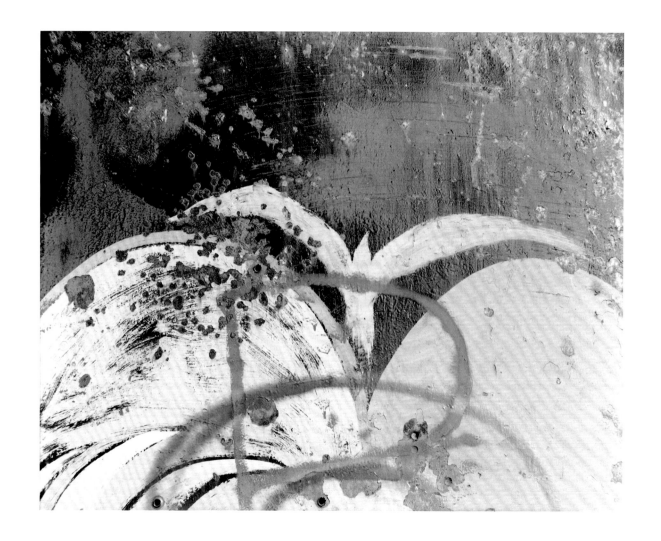

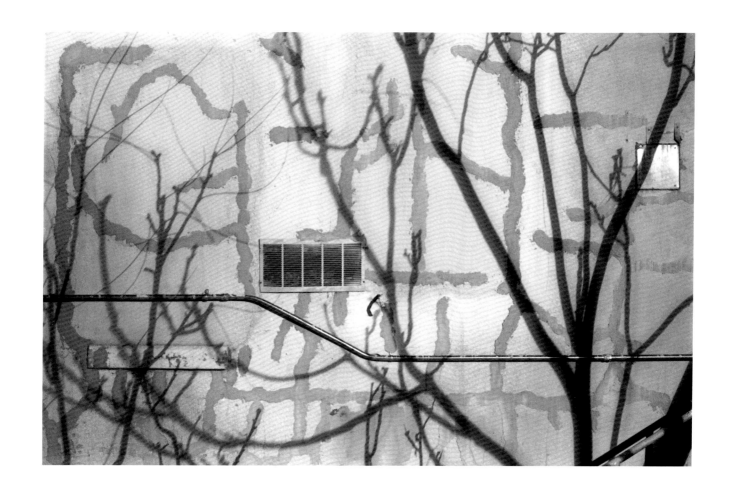

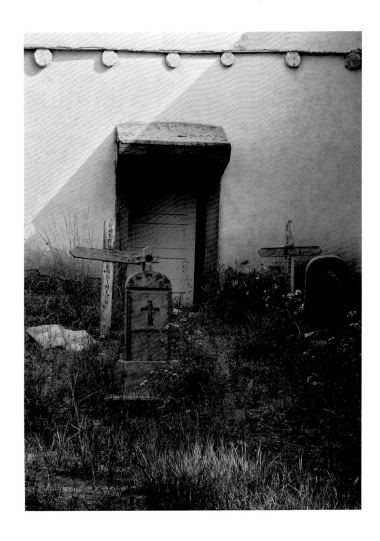

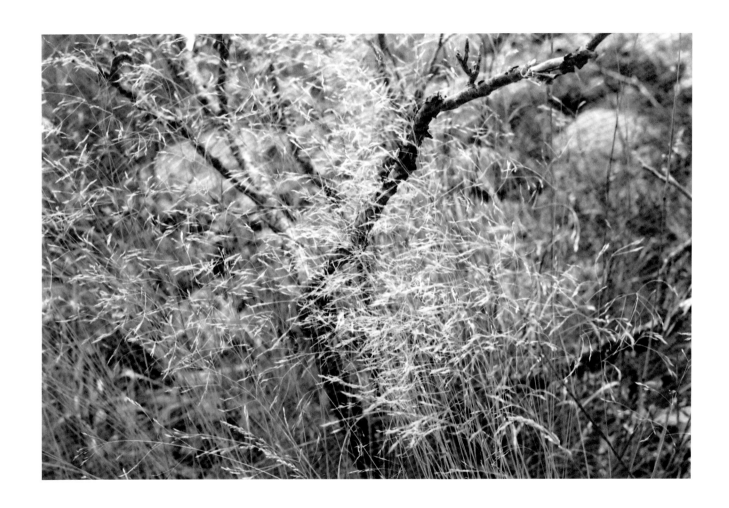

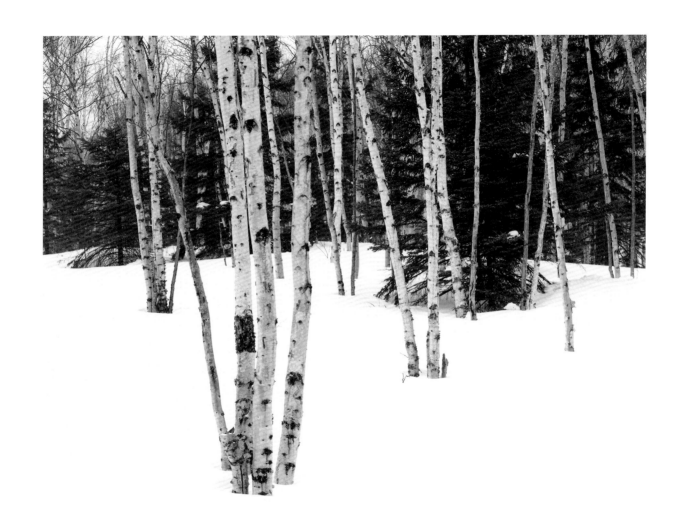

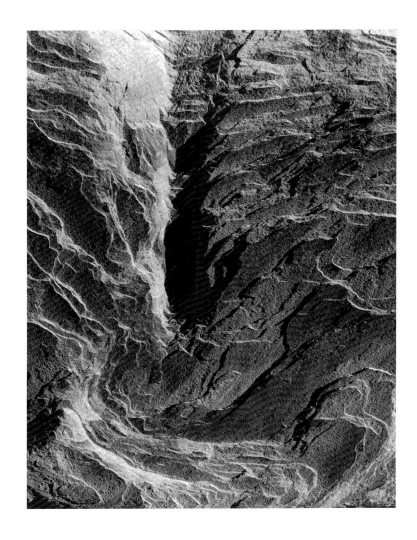

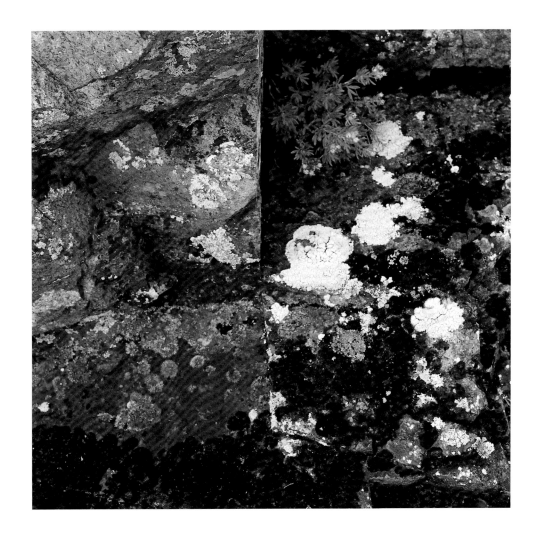

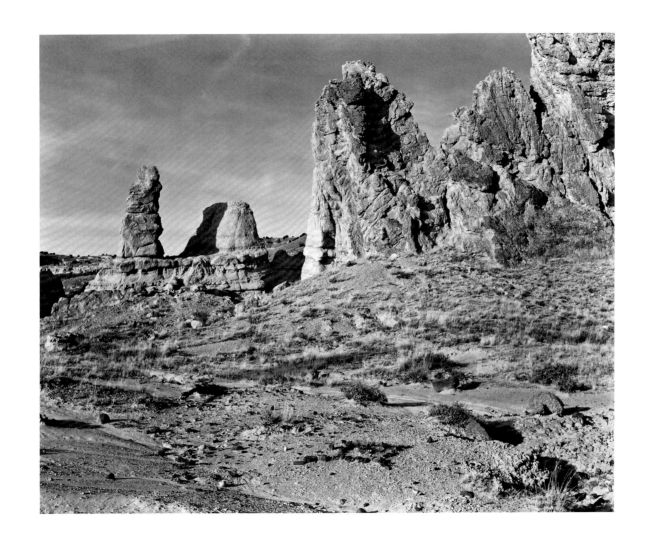

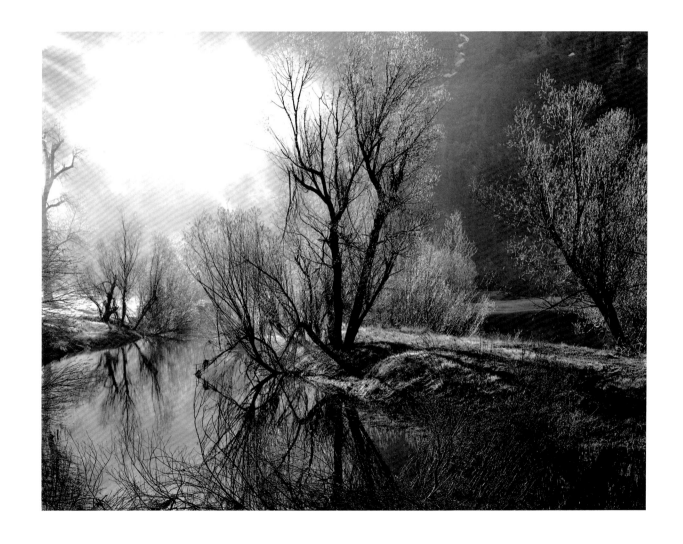

AN APPRECIATION

As I turn each page of *Connections* to meet the next scene, I am struck by nostalgia. The immediacy of the photographs sweeps away the present moment. Ford is there with all his senses alive, in that place in that moment. Having accompanied Ford as he photographed many of these images, I remember sharing our experiences of being there. Our joy comes from reconnecting with these places, some of them favorite places for both of us. Yet each photograph is a refreshingly new view, evoking surprise at seeing detail we usually don't see. Rarely do we absorb all that surrounds the eye; the precise details of a scene are never totally recorded in memory at first glance. In these photographs, the eye is swiftly drawn in to the makeup of things: dancing grass, reflective water, sparkling hoarfrost, stolid horses, lonely barn, and filigree foliage. Now we see particular light falling on particular surface, and deep shadow trailing away down below.

Ford presents images of his journey through the land over many decades, and yet these images may evoke reminiscences of our own paths through the marvels of the world. Viewers of Ford's photographs experience a similar recognition. Can a feeling of reconnection happen despite unfamiliarity with the specific place? All of us have been immersed in the land since childhood, similar places shimmer in overlapping layers in our collective consciousness, in our shared intergenerational history. I join with other viewers of these photographs in shouting, in surprise, "We've been here before!" Ford reminds us all that the land is waiting for us to come home.

<div align="right">Margaret Robbins</div>

PLATES

4 Cottonwoods, La Cienega, New Mexico

7 Death Valley Series #29, California

9 Death Valley Series #55, California

11 Bistahi Series #205, Bisti Badlands, New Mexico

13 Abiquiú, New Mexico

15 Bistahi Series #276, Bisti Badlands, New Mexico

17 Bistahi Series #286, Bisti Badlands, New Mexico

19 Ghost Ranch, Abiquiú, New Mexico [Mesa]

20 Diablo Canyon, Santa Fe County, New Mexico

23 Barn, Noble County, Ohio

25 Meig's Creek, Tennessee

27 Abiquiú Road, New Mexico

29 Hemlocks, Great Smoky Mountains, Tennessee

31 Limberlost #6, Shenandoah, Virginia

PLATES

33 Isle Royale Series #358, Isle Royale, Michigan

35 Ennis, Montana

37 Arboretum Series #70, Globe, Arizona

39 Bistahi Series #298, Bisti Badlands, New Mexico

41 Isle Royale Series #197, Isle Royale, Michigan

42 Cimarron National Grasslands, Kansas

45 Sterling, Alberta, Canada

47 Montezuma, Kansas

49 Highway 50 Near Miesville, Minnesota

51 11th Street, New York City

53 Canyon Road Series #20, Santa Fe, New Mexico

55 Arboretum Series #51, Globe, Arizona

57 Arboretum Series #31, Globe, Arizona

59 Isle Royale Series #203, Isle Royale, Michigan

PLATES

61 Plaza Blanca Series #75, Abiquiú, New Mexico

63 Bistahi Series #246, Bisti Badlands, New Mexico

65 Ramshead Petroglyph, Three Rivers, New Mexico

67 Leaf Rock Petroglyphs, La Cienega, New Mexico

69 Gramineae II, Eldorado, New Mexico

71 Dreamtime #7, Eldorado, New Mexico

73 Dreamtime #28, Madrid, New Mexico

75 Michael's Wall, Santa Fe, New Mexico

77 Cañoncito, New Mexico

79 Gramineae VI, Isle Royale, Michigan

81 Onion River, Minnesota

83 Bistahi Series #280, Bisti Badlands, New Mexico

85 Isle Royale Series #86, Isle Royale, Michigan

87 Plaza Blanca Series #4, Abiquiú, New Mexico

89 Merced River, California

ACKNOWLEDGMENTS

Many people have contributed to the making of this book. Twenty-eight years of exhibiting photographs have produced many observations, favorable and unfavorable, that have undoubtedly influenced my work. Comments from friends and relatives add to the mix. I wish to thank them all. There are, however, a number of individuals whom I wish to thank for their specific support over the years and their input to this project.

Margaret Robbins has been a patient and willing partner as we conceived the format of the book, selected the images, thought through the design, and I hid in the studio for days on end to prepare the work for publication. Her help has been most welcome.

Kent Bowser has been of great support as this project has progressed. I also wish to thank Kent's January Term (Semester Break) classes of 2008 and 2009 at Ghost Ranch, near Abiquiú, New Mexico, for their comments and suggestions as, under my direction, they edited the manuscript as a class project.

My other photo buddies, Ken Schroeder, Duane Monczewski, and David Noble, have provided inspiration and guidance. Nancy Wood, a fine photographer and excellent writer, has long been a major critical "cheerleader" pushing me onward. Michael Bell's guidance over the years has been of immeasurable value. Gene Harrison and Jan and Gale Pietrzak provided valuable comments during the final editing process.

Susan Gardner and Devon Ross, editor and publisher, respectively, at Red Mountain Press, have been invaluable in their advice and support in completing this project in a professional and timely manner. Their friendship and guidance are cherished. John Vokoun's assistance in preparing the images is deeply appreciated.

Finally, I wish to acknowledge the inspiration provided me by my mentor Oliver Gagliani through his workshop and imagery, and by the work of Ray Metzger.

The brief text quotations are from:

David Abram, *The Spell of the Sensuous* (New York: Vintage Books, 1996)
Eva Figes, *Light* (New York: Ballantine Books, 1983). Copyright © Eva Figas. Reproduced by permission of the author c/o Rogers, Coleridge & White Ltd., 20 Powis Mews, London W11 1JN.
Lorine Niedecker, *Lake Superior,* in *Collected Works by Lorine Niedecker,* ed. Jenny Penberthy (Berkeley: University of California Press, 2002)

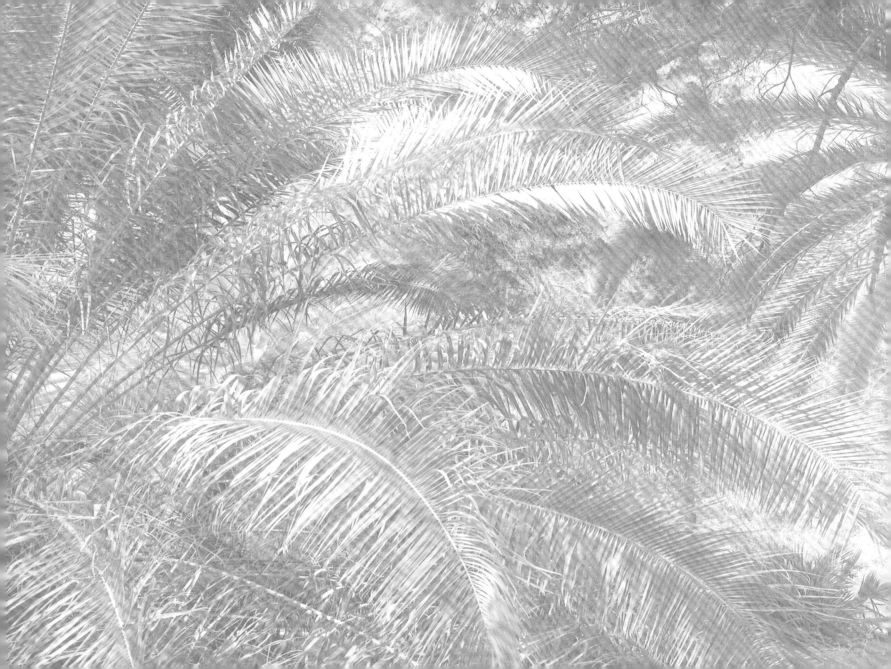